MANGA MAGIC

DRAWING MANGA
GIRLS

ANNA SOUTHGATE AND **KEITH SPARROW**

rosen publishing's
rosen central

NEW YORK

This edition published in 2012 by:

The Rosen Publishing Group, Inc.
29 East 21st Street
New York, NY 10010

Library of Congress Cataloging-in-Publication Data

Southgate, Anna.
Drawing manga girls / Anna Southgate, Keith Sparrow.—1st ed.
 p. cm.—(Manga magic)
Includes bibliographical references and index.
ISBN 978-1-4488-4798-3 (library binding)
ISBN 978-1-4488-4802-7 (pbk.)
ISBN 978-1-4488-4806-5 (6-pack)
1. Girls in art. 2. Comic books, strips, etc.—Japan—Technique. 3. Cartooning—Technique. I. Sparrow, Keith. II. Title.
NC1764.8.G57S68 2012
741.5'1—dc22

2011007882

Manufactured in the United States of America

CPSIA Compliance Information: Batch #S11YA: For further information, contact Rosen Publishing, New York, New York, at 1-800-237-9932.

CONTENTS

Introduction 4

Materials and Equipment 6

Female Figures 10

Female Faces 13

Female Hair 16

Hands and Arms 30

Legs and Feet 34

Female Clothing 46

Glossary 71

For More Information 73

For Further Reading 76

Index 78

INTRODUCTION

From space explorers to schoolgirls to ninjas, girls in manga come from all walks of life. In fact, when it comes to creating female manga characters, your creativity is the limit! Manga (that's pronounced mahn-ga) is a fun and highly stylized art form that originated in comics and graphic stories from Japan. Manga girls can be bold and fierce, like an exorcist priestess, or they can be meek or mousy, like a princess in distress, but in order to tell your story in pictures, you've got to get the look down. That's what this book is for: it will teach you the techniques and tricks to draw your manga girls, one step at a time.

Drawing girls can be tricky. It's all in the anatomy. If you make her shoulders too broad and her hands too big, she won't look girly at all. Eyes, hair, and figure are all very striking aspects of a manga character's look. Will she have long, flowing purple hair or short, black, punky spikes? Are her eyes big and glossy, exuding curiosity, or dark, darting, and mysterious? Part of the fun of creating girl characters is determining their style. After you've got the basics of drawing the body, you can learn how to draw outfits and hairstyles and then come up with a signature pose for your girl to strike.

So, what are you waiting for? Let's get started by looking at the materials we need to get these characters from your imagination to the paper.

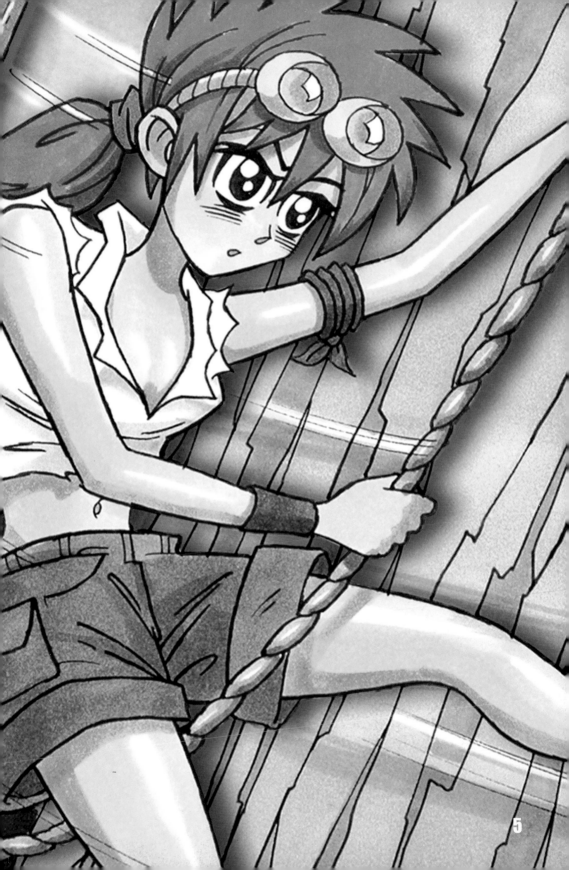

You do not need to spend a fortune to get started in drawing and coloring good manga art. You do, however, need to choose your materials with some care to get the best results from your work. Start with a few basics and add to your kit as your style develops and you figure out what you like working with.

Artists have their preferences when it comes to equipment, but regardless of personal favorites, you will need a basic set of materials that will enable you to sketch, ink, and color your manga art. The items discussed here are only a guide—don't be afraid to experiment to find out what works best for you.

PAPER

You will need two types of paper—one for creating sketches, the other for producing finished color artwork.

For quickly jotting down ideas, almost any piece of scrap paper will do. For more developed sketching, though, use tracing paper. Tracing paper provides a smooth surface, helping you to sketch freely. It is also forgiving—any mistakes can easily be erased several times over. Typically, tracing paper comes in pads. Choose a pad that is around 24 pounds (90 grams per square meter) in weight for best results—lighter tracing paper may buckle and heavier paper is not suitable for sketching.

Once you have finished sketching out ideas, you will need to transfer them to the paper you want to produce your finished colored art on. To do this, you will have to trace over your pencil sketch, so the paper you choose cannot be too opaque or "heavy"—otherwise you will not be able to see the sketch underneath. Choose a paper around 16 lb (60 gsm) for this.

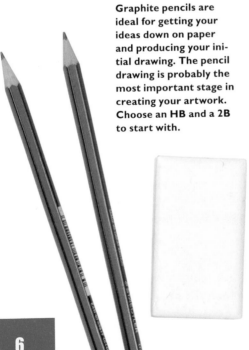

Graphite pencils are ideal for getting your ideas down on paper and producing your initial drawing. The pencil drawing is probably the most important stage in creating your artwork. Choose an HB and a 2B to start with.

The type of paper you use is also important. If you are going to color using marker pens, use "marker" or "layout" paper. Both of these types are very good at holding the ink found in markers. Other paper of the same weight can cause the marker ink to "bleed," that is, the ink soaks beyond the inked lines of your drawing and produces fuzzy edges. This does not look good.

You may wish to color your art using other materials, such as colored pencils or watercolors. "Drawing" paper is good for graphite pencil and inked-only art (such as

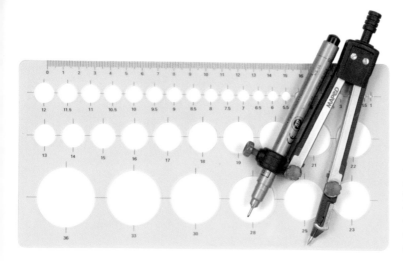

Working freehand allows great freedom of expression and is ideal when you are working out a sketch, but you will find times when precision is necessary.

Use compasses or a circle guide for circles and ellipses to keep your work sharp. Choose compasses that can be adjusted to hold both pencils and pens.

that found in the majority of manga comic books), while heavyweight watercolor paper holds wet paint and colored inks and comes in a variety of surface textures.

Again, don't be afraid to experiment: you can buy many types of paper in single sheets while you find the ones that suit your artwork best.

PENCILS

The next step is to choose some pencils for your sketches. Pencil sketching is probably the most important stage, and always comes first when producing manga art (you cannot skip ahead to the inking stage), so make sure you choose pencils that feel good in your hand and allow you to express your ideas freely.

Pencils are manufactured in a range of hard and soft leads. Hard leads are designated by the letter H and soft leads by the letter B. Both come in six levels—6H is the hardest lead and 6B is the softest. In the middle is HB, a halfway mark between the two ranges. Generally, an HB and a 2B lead will serve most sketching purposes, with the softer lead being especially useful for loose, "idea" sketches, and the harder lead for more final lines.

Alternatively, you can opt for mechanical pencils. Also called self-propelling pencils, these come in a variety of lead grades and widths, and never lose their points, making sharpening traditional wood-cased pencils a thing of the past. Whether you use one is entirely up to you—it is possible to get excellent results whichever model you choose.

SHARPENERS AND ERASERS

If you use wooden pencils, you will need to get a quality sharpener; this is a small but essential piece of equipment. Electric sharpeners work very well and are also

Felt-tip pens are the ideal way to ink your sketches. A fineliner, medium-tip pen and sign pen should meet all of your needs, whatever your style and preferred subjects. A few colored felt-tip pens can be a good addition to your kit, allowing you to introduce color at the inking stage.

very fast; they last a long time too. Otherwise, a handheld sharpener is fine. One that comes with a couple of spare blades can be a worthwhile investment, to ensure that your pencils are always sharp.

Along with a sharpener, you will need an eraser for removing any visible pencil lines from your inked sketches prior to coloring. Choose a high-quality eraser that does not smudge the pencil lead, scuff the paper, or leave dirty fragments all over your work. A soft "putty" eraser works best, since it absorbs pencil lead rather than just rubbing it away. For this reason, putty erasers do become dirty with use. Keep yours clean by trimming it carefully with scissors every now and then.

INKING PENS

The range of inking pens can be bewildering, but some basic rules will help you select the pens you need. Inked lines in most types of manga tend to be quite bold, so buy a thin-nibbed pen, about 0.5 mm (.02 inches) and a medium-size nib, about 0.8 mm (.03 inches). Make sure that the ink in

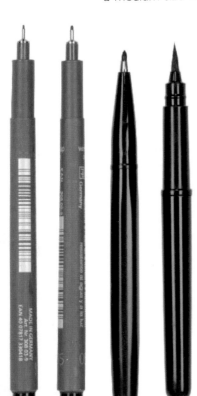

the pens is waterproof; this ink won't smudge or run. Next, you will need a medium-tip felt pen. Although you won't need to use this pen very often to ink the outlines of your characters, it is still useful for filling in small detailed areas of solid black. The Pentel sign pen does this job well. Last, consider a pen that can create different line widths according to the amount of pressure you put on the tip. These pens replicate brushes and allow you to create flowing lines such as those seen on hair and clothing. The Pentel brush pen does this very well, delivering a steady supply of ink to the tip from a replaceable cartridge.

Test-drive a few pens at your art store to see which ones suit you best. All pens should produce clean, sharp lines with a deep black pigment.

MARKERS AND COLORING AIDS

Many artists use markers, rather than paint, to color their artwork, because markers are easy to use and come in a huge variety of colors and shades. Good-quality markers, such as those made by Chartpak, Letraset, or Copic, produce excellent, vibrant results, allowing you to build up multiple layers of color so you can create

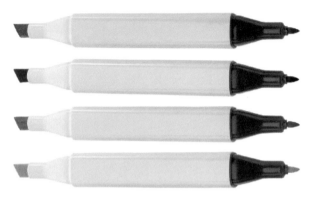

Markers come in a wide variety of colors, which allows you to achieve subtle variations in tone. In addition to a thick nib for broad areas of color, the Copic markers shown here feature a thin nib for fine detail.

rich, detailed work and precise areas of shading. Make sure that you use your markers with marker or layout paper to avoid bleeding. Markers are often refillable, so they last a long time. The downside is that they are expensive, so choose a limited number of colors to start with, and add as your needs evolve. As always, test out a few markers in your art store before buying any.

However, markers are not the only coloring media. Paints and gouache also produce excellent results, and can give your work a distinctive look. Add white gouache, which comes in a tube, to your work to create highlights and sparkles of light. Apply it in small quantities with a good-quality watercolor brush.

It is also possible to color your artwork on a computer. This is quick to do, although obviously there is a high initial cost. It also tends to produce flatter color than markers or paints.

DRAWING AIDS

Most of your sketching will be done freehand, but there are situations, especially with man-made objects such as the edges of buildings or the wheels of a car, when your line work needs to be crisp and sharp to create the right look. Rulers, circle guides, and compasses all provide this accuracy. Rulers are either metal or plastic; in most cases, plastic ones work best, though metal ones tend to last longer. For circles, use a circle guide, which is a plastic sheet with a wide variety of different-sized holes stamped out of it. If the circle you want to draw is too big for the circle guide, use a compass that can hold a pencil and inking pen.

A selection of warm and cool grays is a useful addition to your marker colors and most ranges feature several different shades. These are ideal for shading on faces, hair, and clothes.

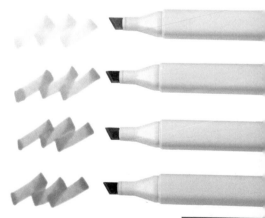

FEMALE FIGURES

THREE-QUARTER VIEW

A basic sense of anatomy and proportion is essential when drawing manga. Here we have a basic female manga character in a relaxed three-quarter-angle pose, with hand on hip, and wearing a simple school uniform consisting of a blouse, sweater vest, skirt, and long socks. The outfit should be secondary to the figure itself, and added after the basic body is constructed.

Now flesh out the body. Draw curved lines down to a trim waist, and then the arms, with her left hand on her hip. Draw her legs and splayed feet, and then indicate breasts.

Give her bangs and a spiky ponytail, then add school-uniform-style clothes. Note how the sleeves and skirt spread out from the body and indicate where the vest creases at the waist.

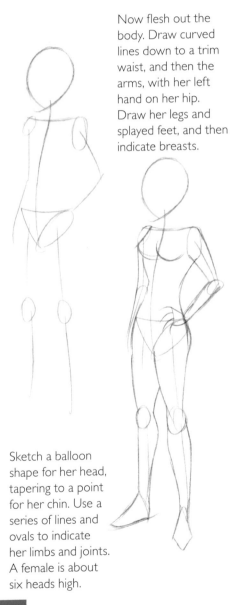

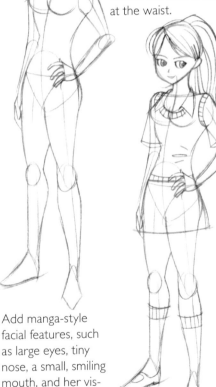

Sketch a balloon shape for her head, tapering to a point for her chin. Use a series of lines and ovals to indicate her limbs and joints. A female is about six heads high.

Add manga-style facial features, such as large eyes, tiny nose, a small, smiling mouth, and her visible left ear. Refine the lines of her left arm and especially her left hand.

BACK VIEW

Try to think of your character as a three-dimensional person, one that you can draw from any angle. To help you with this, take the previous character and draw a back view of her standing. Figure out how low her ponytail falls, and where her various joints and clothes line up. Her body will be roughly symmetrical.

Flesh out the torso, tapering into a tiny waist, then out again over the hips to the line of the skirt. Then draw down the outsides of her legs.

Sketch flowing lines over the head and down her back for hair. Finally add clothing details: the ribbing on the vest, and at the top of the socks, and the short sleeves of her shirt.

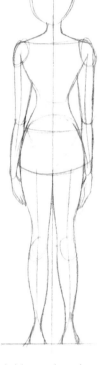

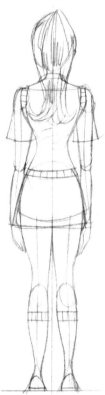

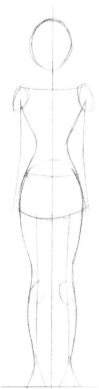

Draw a center line, then add a balloon shape for the head. Draw vertical lines for the arms and legs, and horizontals for the shoulders and waist. Use ovals for the joints, and triangles for the feet.

Add a neck and shoulder blades, then flesh out the arms and draw in hands. Then draw the insides of the legs, so that you have created two separate legs.

PROFILE VIEW

Continuing with the same pose, try to draw your figure from the side, or profile, view. In contrast to the rear view, the profile is not symmetrical, and it's important to understand how the contours of the body line up.

Add a circle for the shoulder joint and an oval for the pelvis. Join the head and pelvis at the back and front, creating the curve of the breast. Then add the leg and foot.

Finally add the clothing details. From this angle, the collar is visible, the sleeve tapers out, and there is a little ribbing around the vest arm-hole and neck. Add the skirt, sock, and shoe.

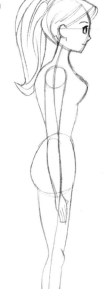

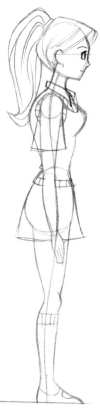

Draw an egg shape for the head, with its point for the chin. The spine is essentially an elongated S-shape and the legs are curved. Draw a horizontal for the floor.

Refine the profile of the face, giving the figure a small nose, then add an eye and eyebrow, the mouth, and a C for the ear. Draw hair on the head and sketch the lines of the ponytail, then add taper-ing lines for the arm and create the individual fingers.

FRONT VIEW

Here's a basic front view of a female face. Most faces are pretty much symmetrical, and the ears, eyes, and nose follow a fairly consistent pattern, with the tops of the ears in line with the top of the eyes, and the nose halfway down toward the chin. The position of the mouth can vary from character to character, but here it sits just over halfway between the nose and chin.

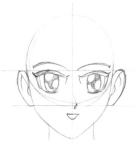
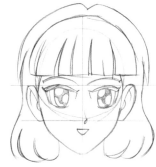

Draw a simple circle, then draw down diagonal lines for the cheeks before turning in and coming to a curving point for the chin. Add a vertical center line, with lines for the neck below.

The eyes are the key in manga faces, so start with these: black pupils with dual highlights. Position the nose, ears, and mouth. Add in eyebrows.

Now add the hair, starting with the chunky bangs. Then, from a center line, take the hair up and bring it down to below chin level. Don't make this too detailed.

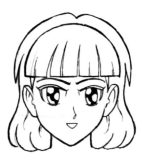
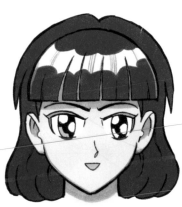

Add color, using pale pink for her face, with beige for shadow areas in the ears, under the bangs, in the mouth, and under the chin. Also use beige for the right pupil and to outline the eyes. Finally, outline a white highlight in the bangs, and color the rest of the hair a vibrant purple.

Ink the main lines, using a thin pen for the eyes, nose, and mouth, with a thicker nib for the outline of the face and the hair. Keep the bangs and hair separate. Color the pupils black.

PROFILE VIEW

Now take the same character and draw it from the side. The relative positions of the eyes, nose, and mouth should be the same. Note how the face outline goes in at the eye area before curving out to a point for the nose and then sloping back diagonally down to the chin. Manga noses are usually tiny and pointed, like this one.

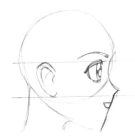

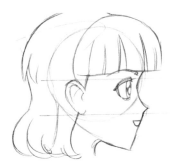

Start with a circle, and then draw a V to make the chin. Add a line for the back of the neck. Then create an indentation and a point to get the profile of the nose.

Add horizontal lines to help with positioning: the ear and eye sit on this line. The double highlight is visible from this angle. Refine the nose and add the mouth.

Draw the hair in two pieces. The bangs form a semicircle, with narrow V-shapes cut in. Draw the curve of the rest of the hair, down to below chin level.

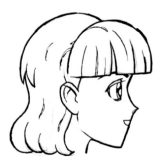

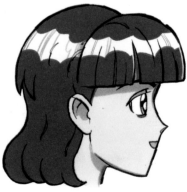

Now ink your sketch. Ink around the face and the two separate blocks of hair. Use a fine pen to outline the mouth. Then color the pupil black.

Color the face pale pink and add beige shadows under the bangs, inside the ear, above and below the eye, inside the mouth, and under the chin. Finally, outline a white highlight in the hair, and color the rest of the hair vivid purple.

AN EYE IN DETAIL

The eye is a more familiar shape, the most important one in a manga face. Eyes are usually extremely large and glossy-looking, with highlights and graceful lashes. This is a typical example, which could be used on all kinds of characters.

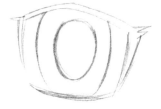

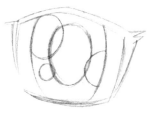

Start with a rough saucepan shape, adding small spikes in the top two corners.

Within the saucepan, draw two curving verticals for the pupils, and an oval shape inside that.

Next, define three areas for highlights, overlapping the pupil.

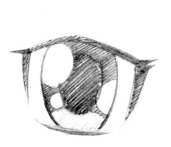

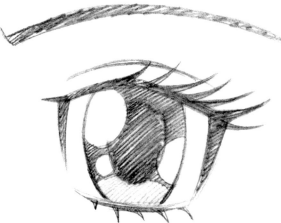

Shade the drawing using darker tones for the pupil and edges of the eye.

Finally, add some sweeping eyelashes and an arched eyebrow.

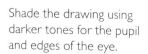

ORANGE BOB

This is a straightforward shoulder-length cut with full bangs. It's softly feminine but can be used on a harder-edged character if needed, so it's very flexible and a good one to practice. The orange color makes it very striking, and glossy white highlights make it look like a healthy head of hair.

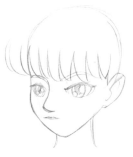

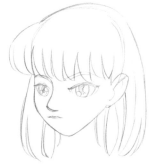

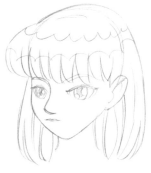

Draw a basic head with large eyes, nose, mouth, and one ear. Then create spiky bangs across the front of the head.

Add the rest of the hair, working from the line of the bangs downward. You want to make the hair fall in thick strands, so you need to make very few lines.

Now outline an area of highlights on the top of the head. Keep the lines bold to work with the rest of the hairstyle.

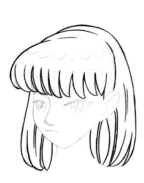

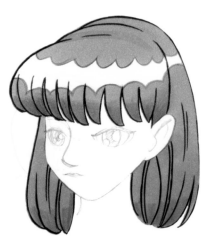

Ink over the main lines of the hair, including the accent lines you created.

Outline the area of highlight above the bangs, then color the rest of the hair bright orange. Go over the color again toward the tips of the hair and bangs to make it darker.

GREEN AND SPIKY

This is a more feisty-looking cut. The large front part is divided into symmetrical bangs, a very popular style in manga. The back is cut quite bushy and short for a tomboyish look, and the color is a very bold shade of green, which is also very popular with manga characters. The key is getting the bangs to look right.

 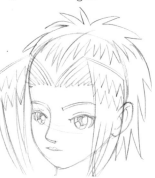

Work a basic head, with eyes, nose, mouth, and one ear. Then create the front of the hairstyle: this sweeps back from a center part, and folds down in front of the ears on both sides.

Now bisect the top of the head with lines running from front to back and from side to side. Add a spiky outline profile to the top of the head and down the figure's left-hand side.

Next add some spiky hair to the front of the head, to sit behind the upswept strands. Outline areas of highlight on the strands that hang down.

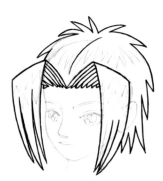 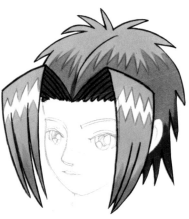

Start to ink the hairstyle. Ink the individual lines of the upsweep, and then outline the spikes hanging down in front of the ears and the rest of the hairstyle.

Create a dramatic color scheme. Use brown for the upsweep and the very tips of hair. Use an acid green for the crown of the head and the front strands, working around the white highlights. Finally, add a darker green to the area you outlined behind the upsweep, on the top of the head.

17

CENTER PART

This style has a slightly more severe look, but it is still a pretty and neat hairstyle. The hair is parted in a sharp divide and swept back behind the ears, leaving a nicely exposed face. It's not too fussy, so it could be used on an action-type character or on a businesswoman. The hair is bright blue, but not too outlandish.

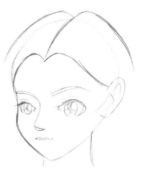

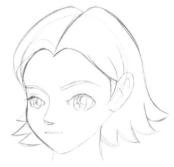

Draw a basic head with eyes, nose, mouth, and ear. Add a center line on top of the head.

From this line, create a Cupid's bow, from which the hair falls down to the ear level.

Add a couple of lines to define the area above the ear. Then add large individual spikes to the ends of the hair on both sides.

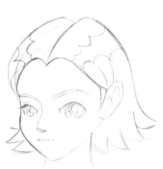

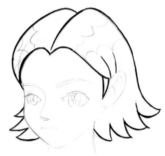

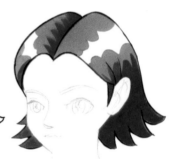

Outline an area of highlights on top of the head on each side of the center part.

Start to ink, outlining the profile of the hair, the center part, a couple of strands above the ear, and a spike in front of the ear.

Color the hair in shades of blue. Leave the highlights you outlined white, then add pale blue around them. Next make areas of darker blue on the ends of the hair.

WITH HEADBAND

There are lots of ways you can dress up the hairstyles on your characters to give them individuality and style. Here we have a wide elasticized headband that sits across the bangs and under the body of the hair at the back. The cut itself is fairly neat and frames the face nicely on either side, with a rich green color.

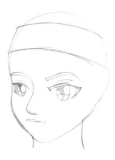

Draw a basic head, with eyes, nose, mouth, and ear. Start the hairstyle with a wide headband across the top of the head.

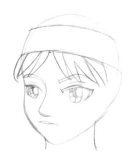

Next, add spiky bangs below the headband. Keep the spikes chunky: you only need three or four above each eye.

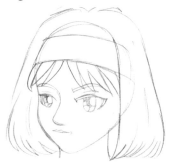

Now create the outline of the hair itself. There are a couple of spikes on the crown, then the hair falls loosely to about shoulder level.

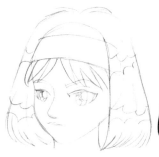

Outline two areas of spiky highlights on both sides of the head, one near the top and one closer to the ends.

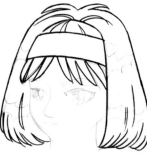

Start to ink. Work around the profile of the hair, the spiky bangs, and the head-band. Ink behind the headband, where the bangs fall.

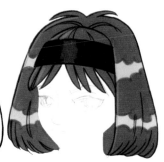

Color the highlights using a pale green. Then choose a darker green for the rest of the hair. Finally, color the headband brown.

19

BLACK AND SPIKY

For a more dynamic image, you can give your character a spiky, boyish cut like this one. The overall shape is a wedge, with heavy spiked bangs swept forward and over the ears. This type of hairstyle is popular with both sexes in manga, and this one is colored a traditional black.

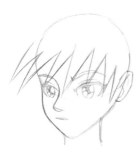
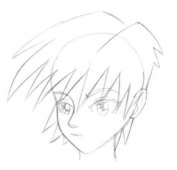
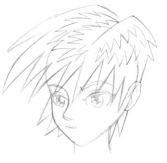

Draw a basic head, with eyes, nose, mouth, and ear. Then create spiky bangs across the face to the ear.

Add a slightly off-center part, and, from the crown, work down into short spikes on both sides. Add a couple of spikes below ear level on both sides.

Outline a dramatic jagged area of highlights close to the part on both sides.

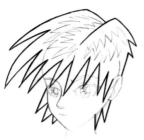
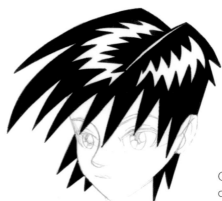

Ink the part, and then ink around the spiky profile of the hair and bangs.

Color this style dramatic black. Work around the highlights you outlined, and leave a small strip next to the part white, too.

BLONDE SWEPT-BACK BOB

This is a much more feminine and pretty cut. The hair is swept back from the forehead to an invisible headband, from which the body of the hair falls down to shoulder level in a gentle sweep. The corn-yellow color suggests a sweet and innocent personality.

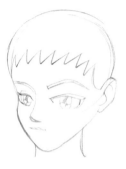

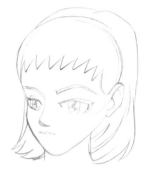

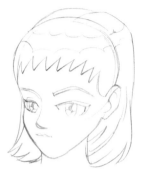

Create a basic head with eyes, nose, mouth, and ear. Then add a swept-back hairline across the front of the head.

Add the crown, with a suggestion of a part, and add hair down to below chin level, creating spiky ends.

Next outline a highlight across the head, behind the bangs, and continue it to the edge of the hair on the right.

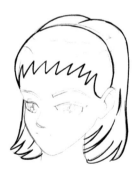

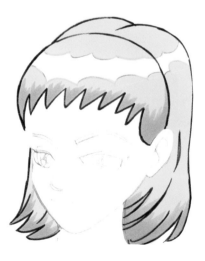

Start to ink. Ink around the bangs and across the top of the head. Then outline the profile of the hair and the part.

Leave the highlights white, and then color most of the hair yellow. Finally, color the ends of the bangs and the hair bright orange.

CURLY PONYTAIL

Here is another feminine hairstyle, perhaps for a more mature female character. It has full bushy bangs falling down to eye level, and a high, full ponytail falling down in the back, before curling up at the end. This is a style that can be endlessly varied in terms of color, to suit lots of different characters.

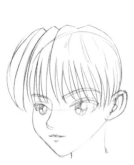

Create a basic head with eyes, nose, mouth, and ear. Add closely spiked bangs, with more widely spaced spikes falling from the top of the head.

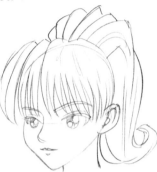

Now add some widely spaced locks from the top of the head, falling down to shoulder level. Finish with a flip.

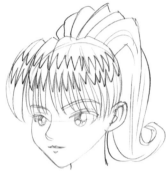

Outline an area of highlights behind the bangs. Make the spikes of this area echo the spikes of the bangs.

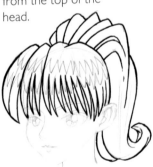

Start to ink. Ink the lines you drew first, then draw the locks from the top of the head, and finally draw those down the back to the flip.

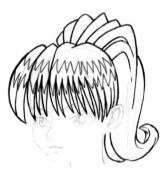

Next outline the highlights behind the bangs.

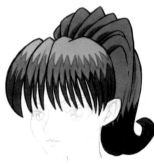

Color the area of highlights in a medium red-brown, color the rest of the hair with a slightly darker shade, and then use a dark brown for the ends of the bangs and hair.

PINK PIGTAILS

Many female manga girls are young and fun-loving. A typical hairstyle for this type of girl could be these huge pink pigtails, held up on either side of the head by hair ties. The size is exaggerated for visual effect, and the bright pink color makes for a high-visibility image. The hair is drawn to look slightly shaggy, with lots of movement.

Draw a basic head with eyes, nose, mouth, and ear. Add chunky, spiky bangs across the face: you only need about half a dozen spikes.

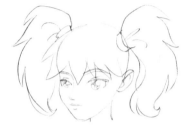

Add a couple of pigtails, one on either side of the head, falling down in loose spiky locks. Secure each with a scrunchie.

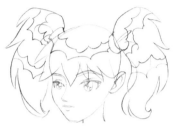

Create highlights behind the bangs, from scrunchie to scrunchie. Then outline a highlight on each pigtail.

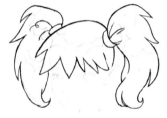

Start to ink, inking the points of the bangs, the top of the head, the scrunchies, and the pigtails. Add a couple of loose strands on each pigtail.

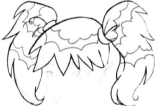

Next, ink the highlights. Choose a violet pen for this: this will help when you start to color.

Color the hair bright pink, up to the highlights. Finally, add some violet ends to the bangs.

WILD SPIKES

This is a dramatic look with a windswept crown of thick spikes. It would indicate a boyish, spunky female with a big personality. The white highlights on top of the head emphasize the upsweep of the spikes behind the head.

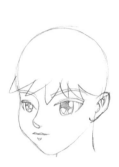

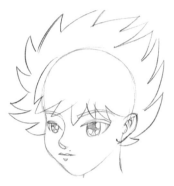

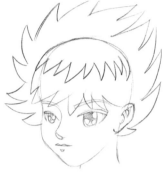

Draw a head with eyes, nose, mouth, and ear. Work chunky, short spiky bangs across the head: only create a few points.

Now create a spiky profile around the whole head, finishing just below the ear.

Indicate an area of highlights behind the bangs, across the top of the head.

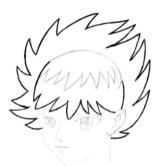

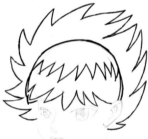

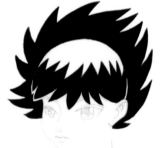

Ink around the outline of the hair, then ink the spikes of the bangs. Take this ink line up to the jagged edge of the highlights.

Next outline the area of highlights around the crown and across the spiky front.

Color your hairstyle jet black. Work up to the highlights you outlined. Leave a couple of white areas so that the spikes of the bangs are seen as separate from the hair.

SLEEK AND BLUE

This is a much more conservative, almost somber hairstyle. It falls down in straight lines from the center part, falls around the ears, and ends in a razor-sharp line at the bottom. The style suggests a serious, straightforward personality.

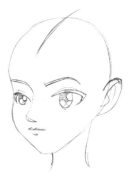 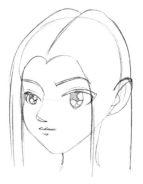 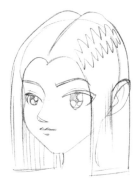

Create a basic head with eyes, nose, mouth, and ear. Start the hairstyle by adding a center part; continue this beyond the top of the head.

From the part line, add hair falling down to shoulder level. Make the front of the style a Cupid's bow and draw the locks down in front of the ear.

Work a jagged highlight near the top of the head, on one side only.

 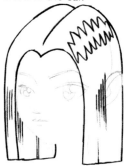

Start inking. Work from the Cupid's bow down to the tips, and from the part down. Ink a few vertical lines in front of the ear and on the left.

Ink the outline of the highlights on the right. This will be left white in the finished sketch.

Color the hair using an ice blue. Then, with a darker blue, color to the left of the part. Also color the underside of the hair on the left, below the ear, and the ends of the hair on the right.

CROPPED RED BOB

This style is for a modern girl with a fast-paced lifestyle, who needs a manageable, neat hairstyle that takes little maintenance. It is brushed forward around and under the ears, and has side-swept, full bangs. The bright red color makes it a very noticeable cut, but it would be easy to tone it down for a more reserved character.

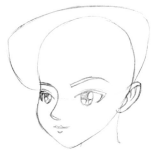

Draw a basic head, with eyes, nose, mouth, and one ear. Create a large profile from the left eye over to the ear.

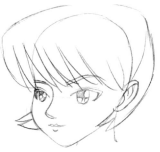

Now work long, spiky bangs across the face. Then add hair to the back of the head and down below the ear. Add a couple of spikes at this same length on the left.

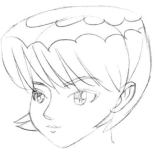

Create broad, spiky highlights across the top of the head.

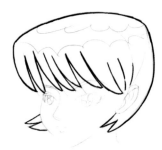

Ink right around the outline of the hair in black.

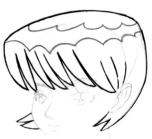

Then, using red, ink the outline of the highlight across the top of the head.

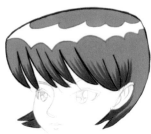

Leaving the highlight white, color the rest of the hair bright red. Then create some darker red ends on the bangs.

CURLY STRANDS

Here is a slightly fussy head of curling strands, which fall down either side of the face and down the back of the head. It's a very feminine, rather old-fashioned style, which would possibly suit a period story. The highlights give it a slightly more up-to-date feel, which could be exaggerated by using different colors.

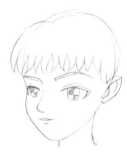

Draw a basic head with eyes, nose, mouth, and one ear. From a point on top of the head create hair that finishes in spiky bangs.

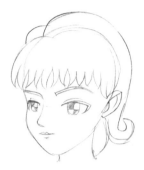

From the top of the head, draw up and then down to shoulder level, creating a flip up. Add an oval next to where you started this piece.

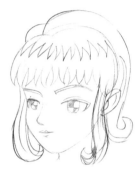

Add a lock of hair in front of the ear, curling this in. Complement this with a similar lock on the left, again curling this in. Draw a spiky line behind the bangs.

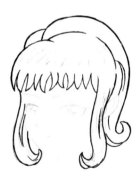

Start inking by outlining the top of the hair, from the part. Then ink the bangs and the curling locks flowing down.

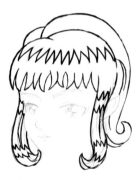

Ink the spiky line that will form the edge of the highlights. Create spiky outlines of more highlights, two on each side of the face.

Color the hair dramatic black, leaving the highlights white.

27

GALLERY

happy
right This is a happy character: her smiling eyes and broad grin need a simple style to emphasize her personality.

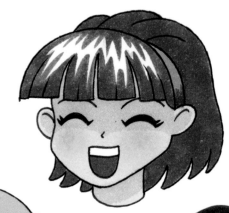

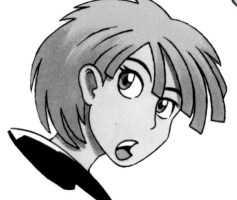

golden shock
above A classic, blonde, spiky style, this complements the guileless blue eyes well. Use a darker shade of gold for shadows under the bangs.

samurai
above This unusual, rather severe style has a hard and shiny appearance, with overtones of a traditional samurai helmet.

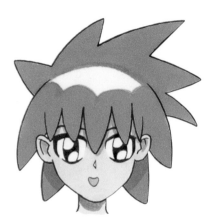

feisty
left Here is a short, boyish style with punky spikes. It suggests that the character has a feisty attitude.

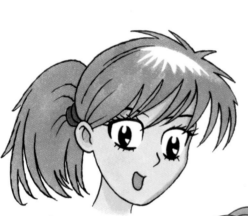

innocent

above Pigtails can be used to make your character look young and innocent, but with a sense of fun. Bright green suggests a cheerful nature.

outgoing

above A standard ponytail in a bright color, this style gives a character a happy, confident, and outgoing personality.

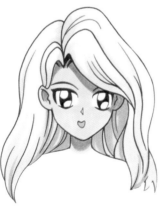
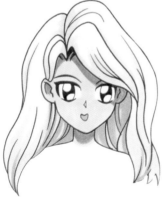

cute

above A style like this one suits younger, girlish characters. The ribbon to complement the large loose ponytail is a good touch.

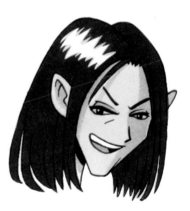

glamorous

above Suitable for slightly older females with sophistication, this style is soft and feminine, with a touch of glamour.

devious

above Long, dark hair and pointy ears suggest a devious nature, a characteristic emphasized by the narrow eyes and lopsided grin.

29

HANGING LOOSE

Much of the time a character's hand may be seen hanging down loosely by his or her side. This is shown as a relaxed downward-pointing profile shape, as here. The fingers can be seen to curl slightly inward, leading away from the index finger: having them all pointing straight down would look unnatural.

 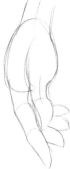

Draw an egg shape. At its top, add two lines to indicate the wrist. Add a center line here, break it, then pick it up and continue out of the bottom of the egg.

Butt an oval up to this line, about halfway along it. Join this to the egg shape with a short line, then add a curved line to flesh out the shape of the thumb.

Draw a line from the left of the egg, down parallel to, and closing in on the first. This is the index finger. Then add the top joints for the three other fingers.

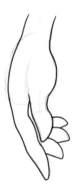 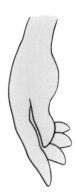 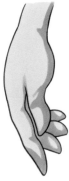

Ink around the edges of the wrist, palm, fingers, and thumb, so that they all are clearly separate from one another. Then erase your pencil lines.

Color the whole of the drawing pink. Make the color solid at this stage: you will be adding shading to indicate shaping and molding at the next stage.

Use tan to add shape to the hand. The areas in shadow are on the right of the wrist and thumb, the right of the index finger, and around the joints.

WAVING OPEN HAND

Here is a graceful, waving hand pose. The look is more feminine and flowing, with slender fingers and smooth lines. Female and male hands follow the same basic construction rules, but those of females can be smaller and smoother.

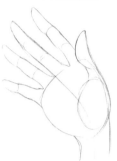

Draw an eggcup shape at an angle of 45°, then close off its top with a curved line. Add a curved line to bisect the basic shape and continue this out and up.

Create the base of the thumb by drawing an oval across the center line and then out to the palm edge. Continue the wrist line up and back to create the thumb.

Draw down from your center line and up and down again to create the first and second fingers. Add the other two fingers. Then create joints on them.

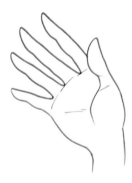

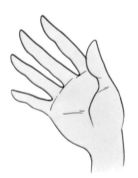

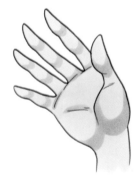

Ink around the whole hand and the individual fingers. Define the edge of the thumb joint across the palm, and ink the crease at the base of each finger.

Now add a flat color to the hand. In this case, a pale pink was used.

Create areas of shadow using a tan color. These include the areas around the joints, across the palm, around the base of the thumb, and at the base of the hand.

BECKONING ARM

Once you have a grasp of hand construction, you can look at how the arm becomes involved. Here is a good pose, with a bended elbow and hand raised up to the shoulder level. It could be used to indicate a summons.

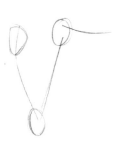

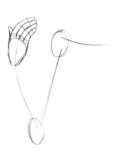

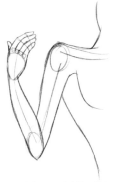

Draw three ovals, in a triangular shape. Make the top left oval broader at the top. Join them together with straight lines, and then add a horizontal line on the right.

Add four circles to the top of the left oval. Then add two lines the width of the oval: these are the joints of the fingers. Draw in four fingers and a thumb.

Now add flesh to the arm. Join the hand to the oval elbow joint, and the elbow to the oval shoulder joint. Add the shoulder and neck, and a line for the side.

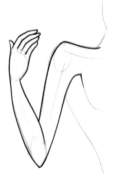

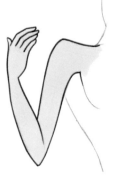

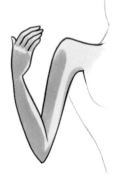

Ink around the shoulder, arm, and hand. Ink the gaps between the individual fingers, and between the index finger and thumb.

Now, introduce some color. Here a flat, pale pink was used to color the hand, arm, and shoulder.

Add shading to suggest the roundness of the arm. Shade the area under the arm, the outside of the upper and lower arm, the back of the hand, and the finger joints.

WAVING ARM

An outstretched arm and hand can be used in a number of ways. Here, the fingers are spread as if trying to grasp onto something, perhaps to stop the figure from falling. This sketch shows that even a fully outstretched arm is not entirely straight.

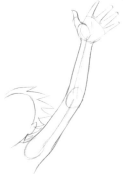

Draw two ovals and then a U-shape, closed with a curved line. Join these three shapes. They are, from bottom to top, the shoulder joint, elbow joint, and hand.

Add an ellipse to the left of the hand for the thumb pad, and add a line coming from it for the thumb. Draw four ovals to create knuckles; then add the fingers.

Finish drawing the thumb and then flesh out the arm. Add a suggestion of a head—here, half an ellipse with an ear shape—and add some spiky hair.

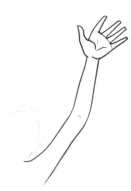

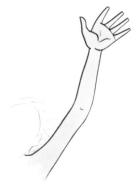

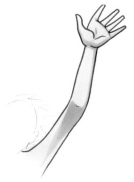

Ink around the arm and the individual fingers. Define the curve of the thumb on the palm, the life line, and the creases at the base of the fingers.

Add some flat color to the arm and hand. In this sketch, a pale pink was used.

Now add shading. Here the upper arm is in shadow. There is also a hint of shadow along the right-hand side of the lower arm and around the palm of the hand.

PROFILE FOOT

This is probably the easiest view of the foot to draw. It shows the angle of the heel as it juts out from the leg, as well as the smooth curve of the instep leading down to the toes. This foot is pointing down as if about to step, so the weight would be on the ball of the foot.

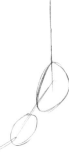

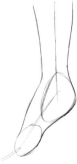

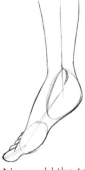

Start with a small oval shape at the bottom. Then draw a larger; rounded triangle shape above it for the heel. Draw a vertical line down for the leg. Then connect the two shapes with an arc, and draw a short upward curve for the toes.

Flesh out the leg shape, working the calf and then the foot. Leave the line for the toe at this point.

Now, add the toes. Start with the big toe; then create smaller curves for the rest of the toes.

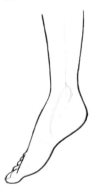

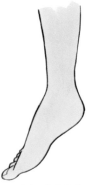

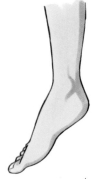

Ink around the outline of the leg, defining the separate toes. Add a nail to the big toe.

Now add a flat tint color over the whole drawing. In this case, pale pink was used.

Create some modeling using dark beige. There is shading down the back of the leg, around the ankle, and under the foot.

TOP OF THE FOOT

This view shows the basic shape of the foot looking down from above. You can see the spread of the toes and the angle in relation to the leg. This foot has a fairly solid contour, suggesting a male, whereas a female foot would usually be more slender at the ankle.

Start with a rounded triangle for the ankle joint. Add a straight line for the leg and another for the foot. Indicate the toes with a curved line at this stage.

Add an ellipse for the pad of the foot; then flesh out the shape of the leg and the foot. Add a curved line to indicate the base of the toes.

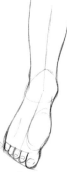

Now flesh out the individual toes and draw the first three toenails; toenails will not "read" on the smallest two toes.

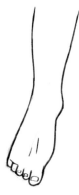

Ink around the whole drawing, separating the toes and inking the nails. Add a couple of lines to suggest the bulge of the instep.

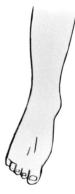

Now color your illustration using a flat pale pink.

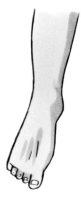

Suggest modeling using a dark beige. There is shading to the right of the leg, along the right-hand side of the foot, and around the instep.

KICKING OUT

Here is a good view of the foot as it kicks out behind a figure in a sharp arc. It could be delivering a blow from a martial artist or be the trailing foot of a diving or flying figure. Note how the foot is pulled back sharply, forming a smooth, continuous line from the leg.

Draw a triangle with rounded edges to represent the heel joint. Bisect this with a straight line for the foot, and a slightly curved one for the toe line.

Flesh out the basic shape of the leg and foot.

Now add the toes, with toenails. Indicate the ankle joint by drawing a small triangle.

 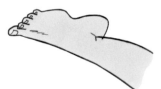 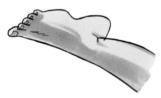

Ink the main lines of the sketch. This includes the leg, heel, ankle joint, toes, and toenails. Suggest the line of the instep.

Color your sketch. Here, a flat pale pink was used.

Use a dark beige to get some shading and modeling into your foot. There is shading on the left-hand side of the leg and foot, and across the toes.

STEPPING OFF

In this drawing, the foot is lifted as if stepping off to the right. It is tilted slightly away from the viewer so you can clearly see the sole and the undersides of the toes. From the heel to the ball of the foot there is an arch that indents in a smooth curve, and you can see the heel is narrower than the ball.

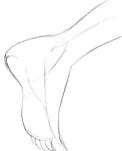

Start by drawing a rounded triangle for the heel. Then add a straight diagonal line up to the right for the leg, and a two-part line down to the bottom right for the foot.

Flesh out the leg and the ball of the foot, with a suggestion of the big toe.

Draw an ellipse for the ball of the foot; then flesh this out into the heel. Draw in the toes.

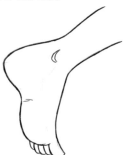

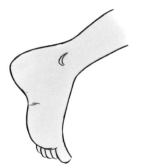

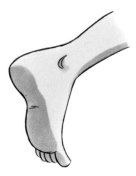

Ink the outline of the leg and foot, including the toes. Ink, too, an indication of the ankle joint and the edge of the footpad.

Color your whole sketch. Here a flat pale pink was used.

Add shading to refine the shape of the leg and foot. Most of the underside of the foot is in shadow, as is an area on the front of the leg and around the ankle joint.

RED ANKLE BOOT

Now we can draw a foot wearing a shoe. Here's a funky little ankle boot with a cuff, which would look good in a fantasy or sci-fi story. It has a thick cushioned sole for comfort, and a white trim detail around the cuff. Note how the upper of the shoe is creased as the foot steps forward, which makes the material of the shoe look soft and pliable.

Draw a rounded triangle for the ankle joint. Add a vertical line for the leg bone, a curve for the top of the foot, a line for the foot itself, and an upright for the line of the toes.

Get some body into the shoe. Make a thick sole; then put a couple of lines in to indicate the top of the shoe.

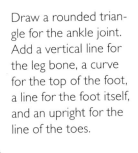

Now add the cuff, with an inverted V detail, and flesh out the leg.

Create the profile of the heel, add a trim detail to the cuff, and indicate a couple of creases in the top of the boot.

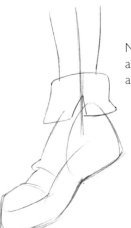

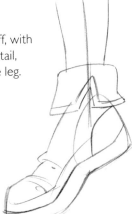

Ink all the main lines, including the creases you outlined in pencil.

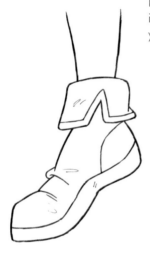

Finally use dark red to indicate shadows on the boot, under the cuff, on the cuff, and on the sole. Use gray for areas of shadow on the welt and sole.

Color the leg pale pink, and then color the boot red. Leave white the trim on the cuff, the heel welt, and the sole.

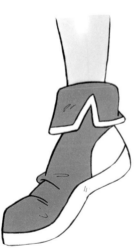

SCHOOL SHOE

The shape of the shoe may vary, but it should always be able to contain a realistic foot shape. This style is a typical school-type shoe, with a sock, probably worn by a young female character. It has a strap closure across the top of the foot and a broad, rounded toe.

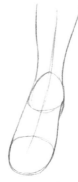

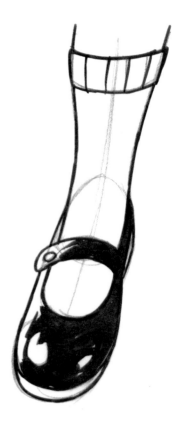

Start with a rough triangle and a rough rectangle, and join them together with straight lines.

Flesh out the foot by joining the triangle and rectangle; then indicate the bottom of a leg.

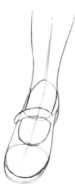

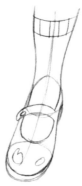

Draw the body of the shoe, with its strap. Define the sole.

Create a couple of highlights, add a fastener to the shoe, and then indicate a ribbed sock.

Ink your sketch. Then, color the shoe black, working around the highlighted areas you defined. The shoe now has the appearance of shiny patent leather.

BALLET FLAT

This ballet flat is a very common everyday shoe worn by female manga characters. It sits snugly around the foot, and has a thin, flat sole, comfortable for walking around town. Make sure that the foot shape is established under the outline of the shoe to ensure an accurate and believable piece of footwear.

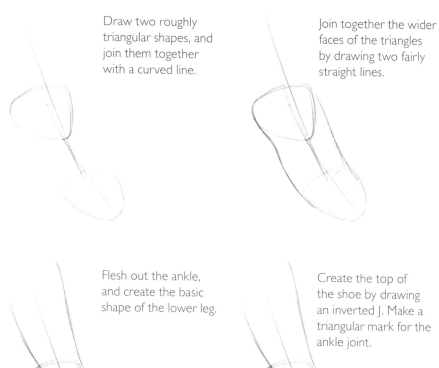

Draw two roughly triangular shapes, and join them together with a curved line.

Join together the wider faces of the triangles by drawing two fairly straight lines.

Flesh out the ankle, and create the basic shape of the lower leg.

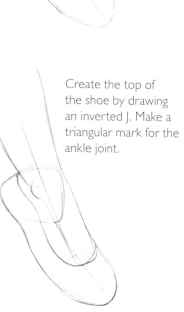

Create the top of the shoe by drawing an inverted J. Make a triangular mark for the ankle joint.

Ink the main lines
of the leg and shoe,
including the ankle
joint. Then erase any
pencil lines and clean
up the illustration.

Finally color the leg
pale pink. Then get
some shading onto
the leg to suggests its
roundness.

Color the shoe a flat,
dark purplish blue.

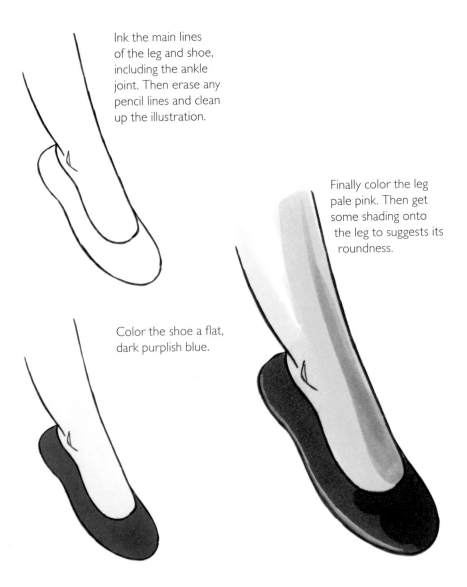

CHUNKY-HEEL BOOT

Some female characters wear a higher-heel boot for extra lift. This style is a chunky, stack-heeled boot with a zip-up side and flat, wide toe. You can see how the heel curves around the back of the foot in a smooth line, then creases slightly as the calf bows outward again.

Draw a rough triangle, with a curved line cutting through it.

Draw a vertical line roughly parallel to the first. Then create the heel of the boot from the base of the triangle and the profile of the front and sole.

Flesh out the rest of the boot. Then redefine the sole, and create the third dimension for the heel.

Add some detailing on the side of the boot, create the detailing on the heel, and add shading. Then, create some creases on the front and around the ankle.

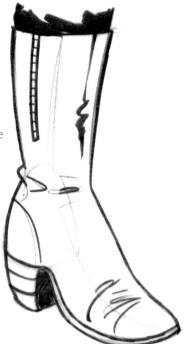

Ink the main lines, including the creases. Then use black to define the top of the boot and make the shading on the heel.

LEATHER SLIP-ON

This is another sensible-looking shoe, suitable for a young female office worker or professional woman. It's made of smart brown leather with moccasin-style piping and a button-down strap across the top. The heel is quite high, but is still sensible-looking.

Start by drawing a couple of ellipses, and join them together with a curved line.

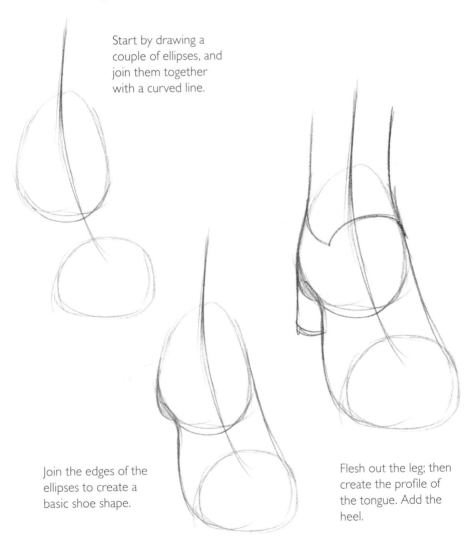

Join the edges of the ellipses to create a basic shoe shape.

Flesh out the leg; then create the profile of the tongue. Add the heel.

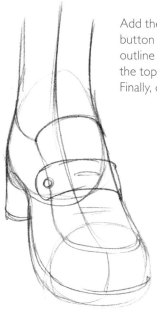

Add the strap with its button detail. Then outline the leather on the top of the shoe. Finally, draw the sole.

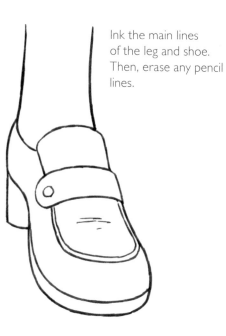

Ink the main lines of the leg and shoe. Then, erase any pencil lines.

Color the shoe tan and make the sole honey-colored. Add some blue shading to the leg to get a sense of roundness into it.

Finally, take some opaque white and use it to work some highlights on the upper and on the button detail.

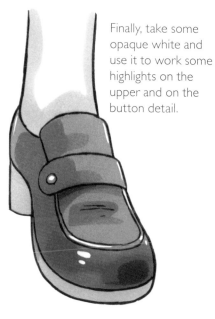

TOP AND SKIRT

This is a simple outfit that is easy to draw and suitable for a younger female character in a modern story. The top is fitted close to the body, and the skirt is short and flares out from the hips. Socks and flats are common fashion items for girls in manga stories.

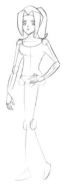

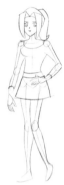

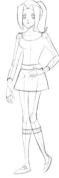

Create a figure from basic lines and ovals, and add face and hair. Flesh out the torso and arms, and then create the profile of the breasts. Add a rounded neckline.

Finish the outline of the top at the waist and cuffs; then add a short skirt. Add flesh to the legs, and give the figure basic feet.

Outline the socks and Mary-Jane-style shoes. Give the socks typical ribbed cuffs.

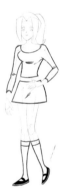

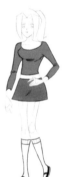

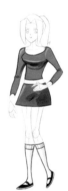

Ink the outline of the top, skirt, and socks. Also ink creases at the elbows, under the breasts, and on the skirt. Use black ink to color the shoes.

Add some flat color. Here, red has been used for the crop top, and gray for the skirt.

Finally, introduce some shading using darker tones of gray and red to suggest the folds in the fabric, and improve the modeling on the figure.

CITY SUIT

If your character works in an office, she might wear something like this smart two-piece suit, with a long, sensible skirt and white blouse with a tie. Add a little splash of color with some caramel-colored loafers.

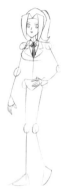 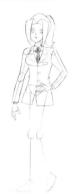 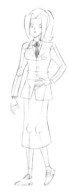

Draw a basic figure from lines and ovals, and add a face and hair. Start the outfit at the neck by drawing a collar, lapels, and a shaded necktie.

Complete the lines of the jacket, giving it a button trim, sleeves, and a breast pocket.

Next add a below-knee skirt. Then flesh out the legs and feet, giving the character short socks and athletic shoes.

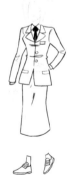 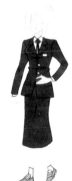 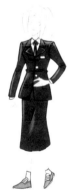

Ink all the main lines. Color the tie black, then suggest creases at the elbows, under the breast, around the waist, and on the skirt. Outline the pocket trims.

Color the suit dark gray, and then make the shoes a pale shade of caramel. Leave white cuffs for the shirt, white buttons, and a white breast-pocket trim.

Finally, work some subtle shading around the shoulders, along the arms, on the side, and in the shadow area created between the legs.

HIKING OUTFIT

This is an outfit suitable for a hiking trip, with a knit sweater for keeping warm in the cool mountain air and sensible shorts for warmer valleys. The colors are all earthy and natural to emphasize the practical nature of the clothes. The sweater is a loose fit, as shown by the creases and folds around the waist and arms.

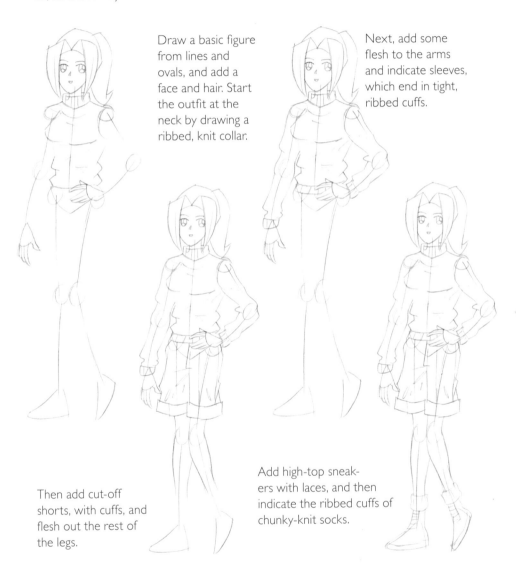

Draw a basic figure from lines and ovals, and add a face and hair. Start the outfit at the neck by drawing a ribbed, knit collar.

Next, add some flesh to the arms and indicate sleeves, which end in tight, ribbed cuffs.

Then add cut-off shorts, with cuffs, and flesh out the rest of the legs.

Add high-top sneakers with laces, and then indicate the ribbed cuffs of chunky-knit socks.

Ink the main lines, and include an indication of folds and creases under the breasts and around the crotch area.

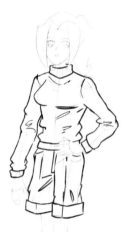

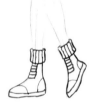

Add flat color: the top is brown and the shorts a shade of caramel. Then color the shoes red-brown, leaving the laces white, and make the socks a shade of charcoal gray.

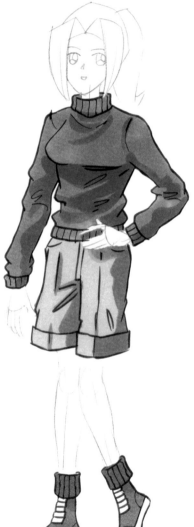

Finally, add shading in darker tones, to give body and strength to your drawing.

SUMMER DRESS

Here's a simple but feminine summery dress, which has a bold, striped pattern and wide, flowing skirt. This look suggests a happy, pleasant personality and an air of innocence, and would look appropriate for a country walk or a picnic in the park.

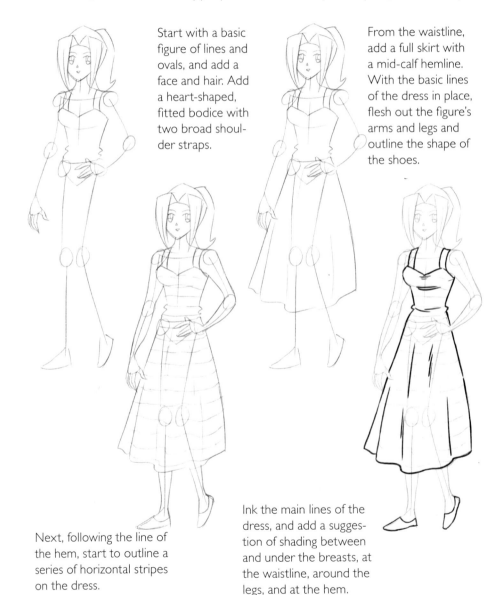

Start with a basic figure of lines and ovals, and add a face and hair. Add a heart-shaped, fitted bodice with two broad shoulder straps.

From the waistline, add a full skirt with a mid-calf hemline. With the basic lines of the dress in place, flesh out the figure's arms and legs and outline the shape of the shoes.

Next, following the line of the hem, start to outline a series of horizontal stripes on the dress.

Ink the main lines of the dress, and add a suggestion of shading between and under the breasts, at the waistline, around the legs, and at the hem.

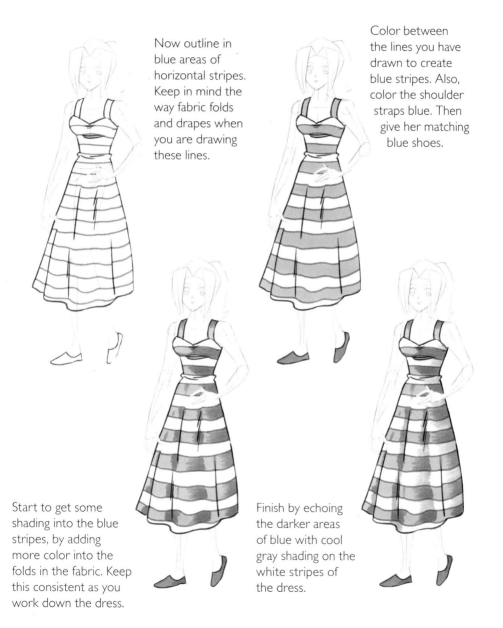

Now outline in blue areas of horizontal stripes. Keep in mind the way fabric folds and drapes when you are drawing these lines.

Color between the lines you have drawn to create blue stripes. Also, color the shoulder straps blue. Then give her matching blue shoes.

Start to get some shading into the blue stripes, by adding more color into the folds in the fabric. Keep this consistent as you work down the dress.

Finish by echoing the darker areas of blue with cool gray shading on the white stripes of the dress.

SCHOOLGIRL

The school uniform is a very common form of dress in many manga stories. The outfit can vary from story to story, but is usually based on a simple sailor-style outfit like the one shown here. The collar is a broad V-shape, with a large bow tied underneath. The top itself is white, and is worn with a short pleated skirt.

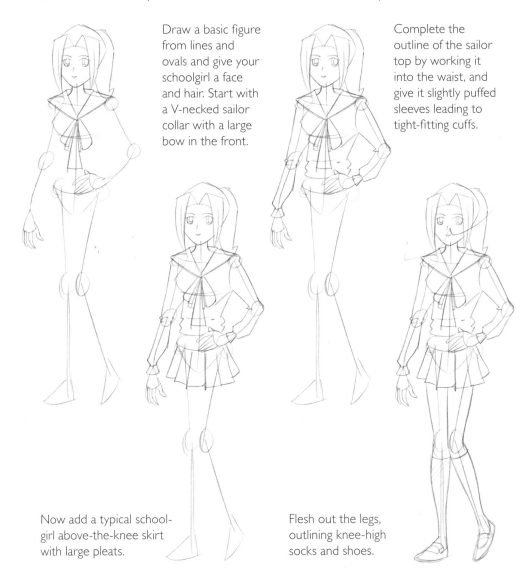

Draw a basic figure from lines and ovals and give your schoolgirl a face and hair. Start with a V-necked sailor collar with a large bow in the front.

Complete the outline of the sailor top by working it into the waist, and give it slightly puffed sleeves leading to tight-fitting cuffs.

Now add a typical school-girl above-the-knee skirt with large pleats.

Flesh out the legs, outlining knee-high socks and shoes.

Ink the lines of the top, with its sailor collar, and the pleated skirt. Also ink the socks and the main lines of the shoes.

Color the outfit. Typical colors are white with a blue collar for the shirt, and gray for the skirt. Make the socks black, and the shoes gray.

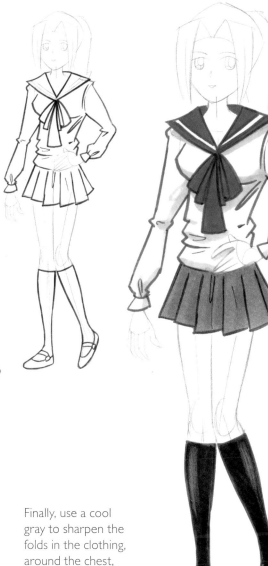

Finally, use a cool gray to sharpen the folds in the clothing, around the chest, under the collar, on the sleeves, and around the midriff.

POLLYANNA STYLE

Another popular style for manga females is the "Pollyanna." The look is frilly Victorian-era with a long, flowing skirt and puffed sleeves. It can be used in a period story or as an eccentric alternative look in a modern-day tale.

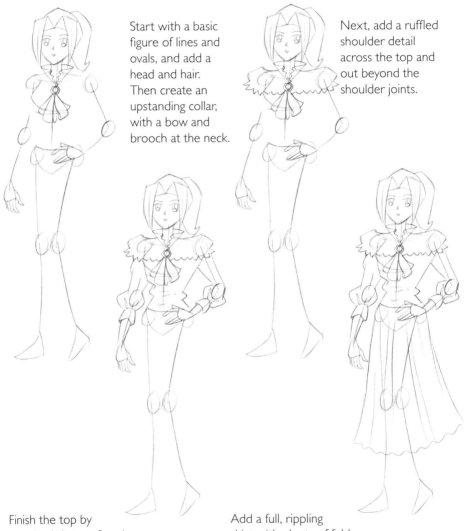

Start with a basic figure of lines and ovals, and add a head and hair. Then create an upstanding collar, with a bow and brooch at the neck.

Next, add a ruffled shoulder detail across the top and out beyond the shoulder joints.

Finish the top by drawing it in to a fitted waist. Then give it full sleeves into fitted cuffs.

Add a full, rippling skirt with plenty of folds, falling down to just above ankle level.

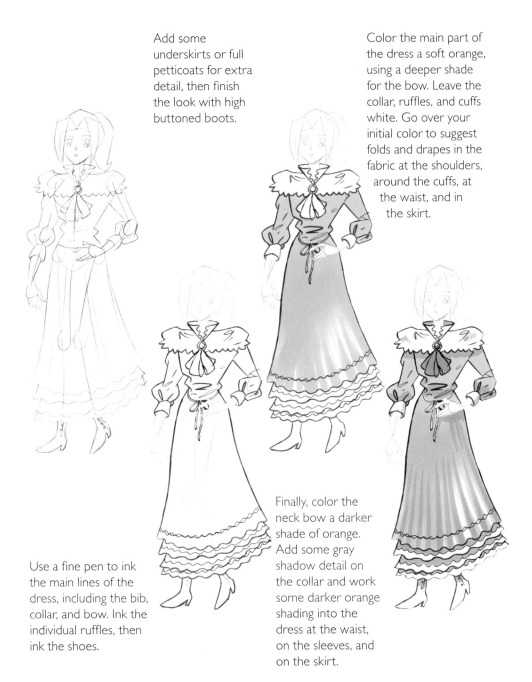

Add some underskirts or full petticoats for extra detail, then finish the look with high buttoned boots.

Color the main part of the dress a soft orange, using a deeper shade for the bow. Leave the collar, ruffles, and cuffs white. Go over your initial color to suggest folds and drapes in the fabric at the shoulders, around the cuffs, at the waist, and in the skirt.

Use a fine pen to ink the main lines of the dress, including the bib, collar, and bow. Ink the individual ruffles, then ink the shoes.

Finally, color the neck bow a darker shade of orange. Add some gray shadow detail on the collar and work some darker orange shading into the dress at the waist, on the sleeves, and on the skirt.

GIRL RACER

Here's a more streamlined look for a futuristic girl in a one-piece jumpsuit. The helmet could be for a high-powered motorbike, or part of a spacesuit. The suit is fitted closely around the neck with a zipper, and includes skintight gloves and boots. It has a bold, striking pattern in red and white, for high visibility.

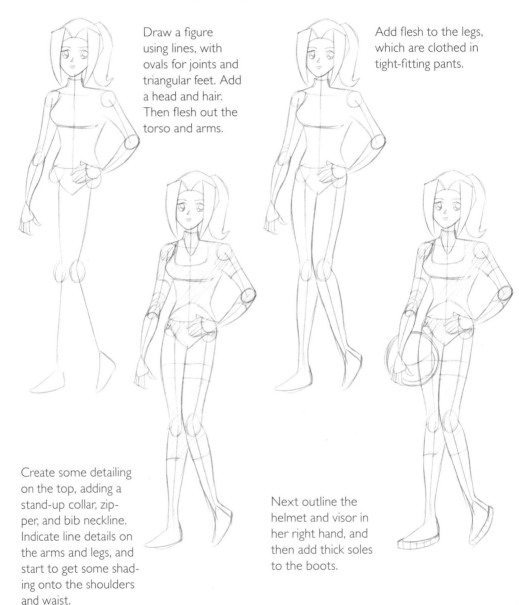

Draw a figure using lines, with ovals for joints and triangular feet. Add a head and hair. Then flesh out the torso and arms.

Add flesh to the legs, which are clothed in tight-fitting pants.

Create some detailing on the top, adding a stand-up collar, zipper, and bib neckline. Indicate line details on the arms and legs, and start to get some shading onto the shoulders and waist.

Next outline the helmet and visor in her right hand, and then add thick soles to the boots.

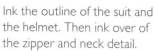

Ink the outline of the suit and the helmet. Then ink over of the zipper and neck detail.

Color most of the top red, and add red detailing on the arms and around the legs. Make the boots red, and add red details on the helmet.

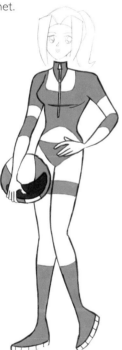

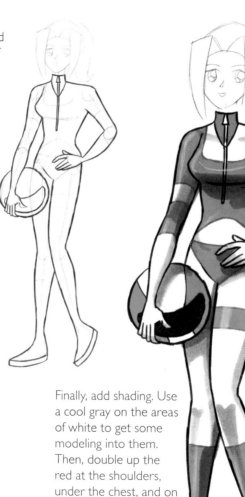

Finally, add shading. Use a cool gray on the areas of white to get some modeling into them. Then, double up the red at the shoulders, under the chest, and on the boots. Finally, add white highlights on the shoulders, arms, and fronts of the legs.

WARRIOR WOMAN

Give your character a tough warrior look with this gladiator outfit, complete with leather-style sandals and slashed-open skirt flaps. The jacket is cut to the shoulders and buttoned across the lapels in a military style. Add arm coverings and wristbands, and complete the look with a headband.

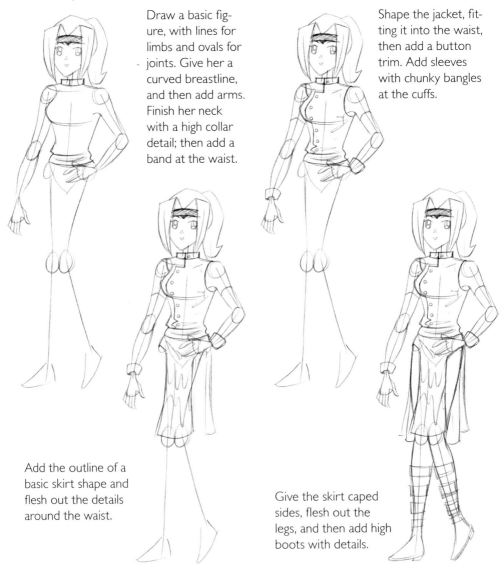

Draw a basic figure, with lines for limbs and ovals for joints. Give her a curved breastline, and then add arms. Finish her neck with a high collar detail; then add a band at the waist.

Shape the jacket, fitting it into the waist, then add a button trim. Add sleeves with chunky bangles at the cuffs.

Add the outline of a basic skirt shape and flesh out the details around the waist.

Give the skirt caped sides, flesh out the legs, and then add high boots with details.

Ink the lines of the jacket, sleeves, bangles, skirt, and boots. Ink the buttons separately.

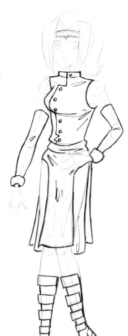

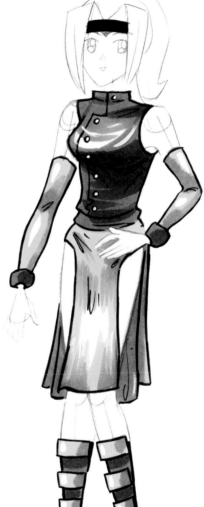

The color scheme here is yellow and green, so make the jacket and boots green, along with the bangles, while the skirt, sleeves, and boot trim are yellow. Leave some white highlights on the front of the jacket to suggest creases and folds.

Color the buttons yellow, then introduce some dark beige shading on the sleeves, in the folds of the skirt, and on the yellow trim on the boots.

TRENCH COAT

Lots of manga characters wear long, flowing trench coats like this one. The loose, flapping shape is great for dramatic effect and looks very elegant and stylish. Here the look is coupled with long thigh-length boots and a heart-shaped top.

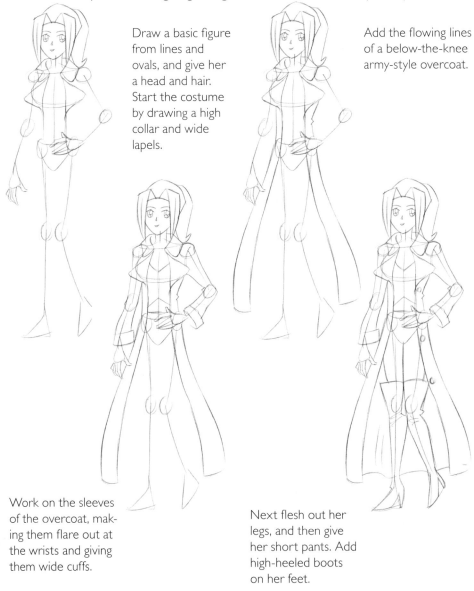

Draw a basic figure from lines and ovals, and give her a head and hair. Start the costume by drawing a high collar and wide lapels.

Add the flowing lines of a below-the-knee army-style overcoat.

Work on the sleeves of the overcoat, making them flare out at the wrists and giving them wide cuffs.

Next flesh out her legs, and then give her short pants. Add high-heeled boots on her feet.

Ink the outline of the top, pants, coat, collar, lapels, and cuffs, and her legs. Then outline the buttons.

Color the pants choco- late brown and make the overcoat honey, with a deeper brown lining.

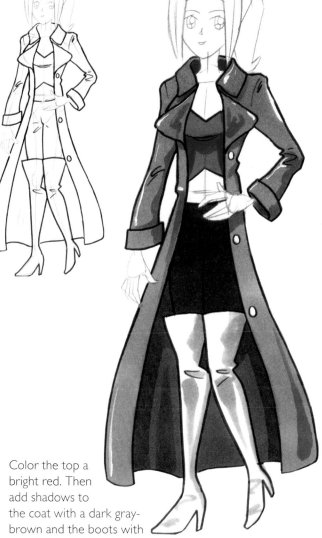

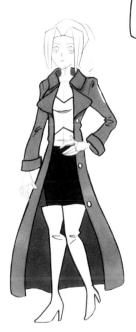

Color the top a bright red. Then add shadows to the coat with a dark gray- brown and the boots with a cool gray. Finish with some white highlights on the sleeves and lapels.

EVENING DRESS WITH SCARF

For a sophisticated evening look suitable for all kinds of formal events and parties, try this long, slim evening dress and coordinating scarf. The cut is designed to follow the body in smooth curves, and is cut a little way up between the shins so that it flares out slightly. The scarf hangs casually over the shoulders and hangs down the back almost to the floor.

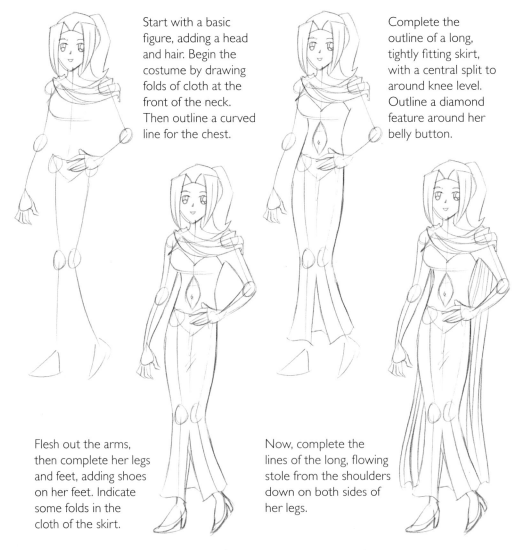

Start with a basic figure, adding a head and hair. Begin the costume by drawing folds of cloth at the front of the neck. Then outline a curved line for the chest.

Complete the outline of a long, tightly fitting skirt, with a central split to around knee level. Outline a diamond feature around her belly button.

Flesh out the arms, then complete her legs and feet, adding shoes on her feet. Indicate some folds in the cloth of the skirt.

Now, complete the lines of the long, flowing stole from the shoulders down on both sides of her legs.

Ink the lines of the dress, stole, shoes, and ankle straps. Ink all the folds of the stole, and then create some shading lines down the center of the dress and under the breasts.

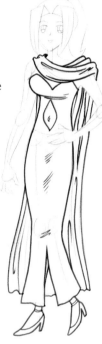

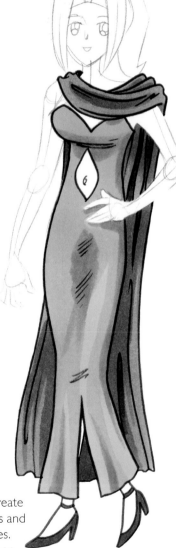

Choose a strong acid green for the dress, leaving the area around her navel white. Then use a dark green for the long, draped stole. Color her shoes grayish green.

Take darker shades of both greens to create the shadows of folds and creases in the clothes. Outline the line of her legs, to highlight the sleek profile of the dress.

CROP TOP AND JEANS

This is a casual street look for a cool young female. The style is slightly punk, with a torn, sleeveless tee shirt, cuffed jeans, and red basketball sneakers, and she's holding a jacket loosely in her hand.

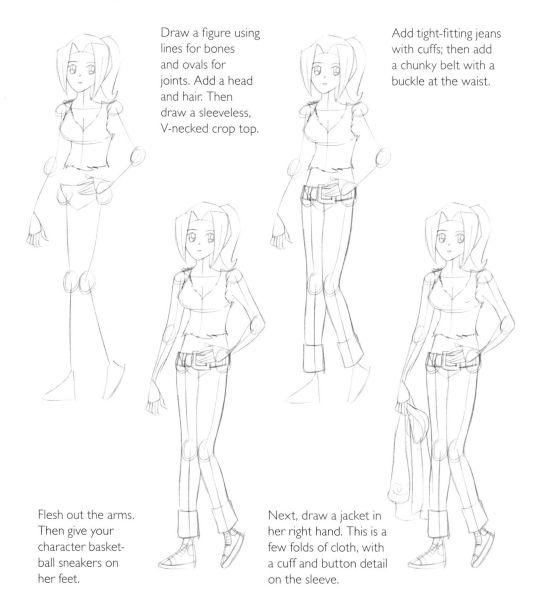

Draw a figure using lines for bones and ovals for joints. Add a head and hair. Then draw a sleeveless, V-necked crop top.

Add tight-fitting jeans with cuffs; then add a chunky belt with a buckle at the waist.

Flesh out the arms. Then give your character basketball sneakers on her feet.

Next, draw a jacket in her right hand. This is a few folds of cloth, with a cuff and button detail on the sleeve.

Ink your sketch. Make the crop top edges read as torn. Ink in the fly and all the belt and buckle details. Then ink the profile of the chest and some creases around the crotch.

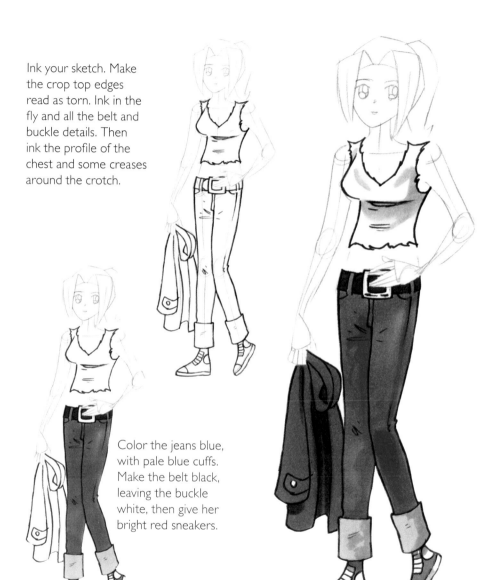

Color the jeans blue, with pale blue cuffs. Make the belt black, leaving the buckle white, then give her bright red sneakers.

Work the jacket in shades of gray, then use a light gray on the top to get some shading here. Finally add shadows to the jeans using darker shades of blue.

BATTLE ARMOR

If your character is facing battle in the far reaches of space, a suit of reinforced metallic armor like this is essential. The armor itself covers the most vulnerable areas of the body and is worn over a thin, flexible black leotard made of extra-strength thread. Armor can be drawn as a series of randomly assorted shapes, but it must be convincing to the viewer.

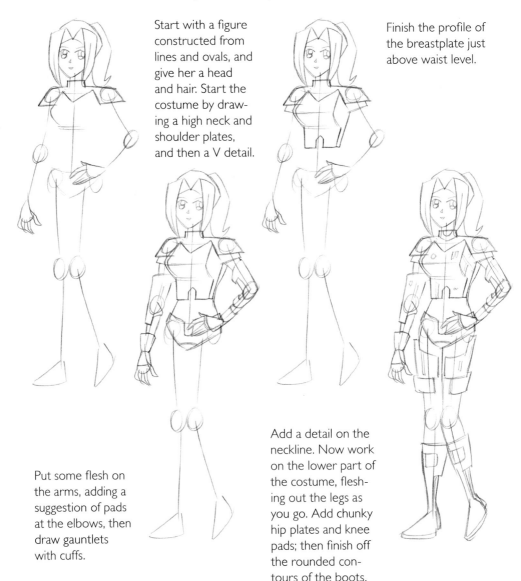

Start with a figure constructed from lines and ovals, and give her a head and hair. Start the costume by drawing a high neck and shoulder plates, and then a V detail.

Finish the profile of the breastplate just above waist level.

Put some flesh on the arms, adding a suggestion of pads at the elbows, then draw gauntlets with cuffs.

Add a detail on the neckline. Now work on the lower part of the costume, fleshing out the legs as you go. Add chunky hip plates and knee pads; then finish off the rounded contours of the boots.

Ink all the main lines to
define the shape of the
costume more closely: the
shoulders and breastplate
are fairly square, as are the
hip guards and knee plates.

Color the leotard black
to make the metallic
armor pieces stand out.

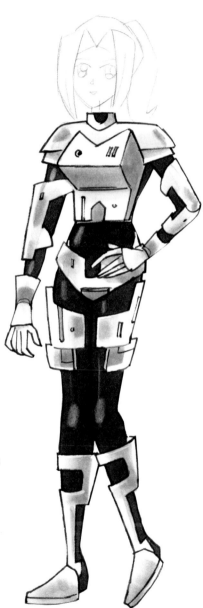

Use a variety of grays
to add shading to
the armor pieces,
suggesting a metal-
lic finish, and make
the shadows darker
where necessary.
Add a little white
highlighting on the
knees and hips for
extra depth.

GALLERY

feisty

right There are stories for all age groups in manga. For the very young, the "chibi" style, in which normal characters are compressed into exaggerated, cute proportions, such as this figure, is very popular.

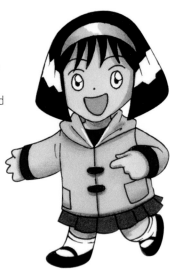

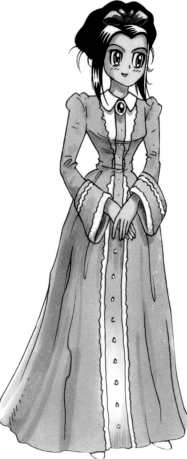

period style

left Stories with period settings are popular in several manga subgenres, and it can be great fun drawing historical fashions on your characters.

fashionable

below This is a contemporary figure. Japanese girls can be very fashion-conscious and this is reflected in some modern manga stories.

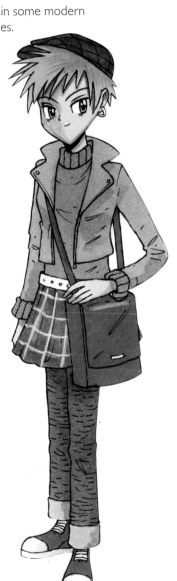

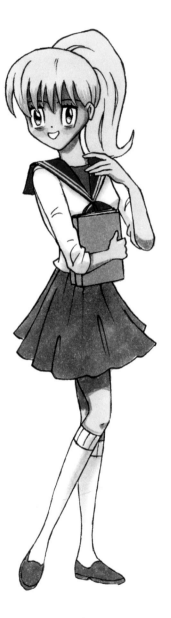

schoolgirl

above The sailor-suit school uniform is a common sight in manga, as are stories with a school theme.

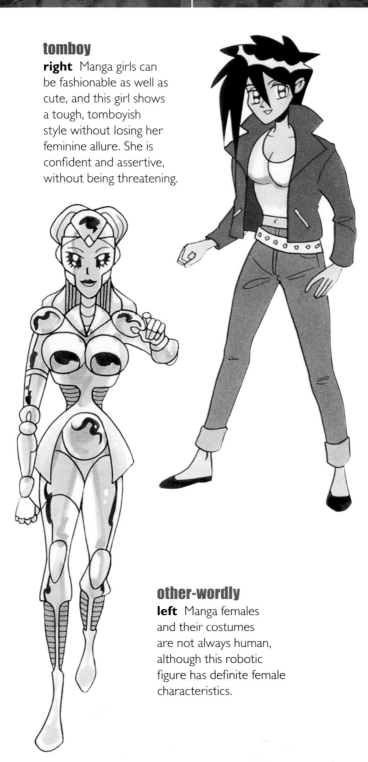

tomboy

right Manga girls can be fashionable as well as cute, and this girl shows a tough, tomboyish style without losing her feminine allure. She is confident and assertive, without being threatening.

other-wordly

left Manga females and their costumes are not always human, although this robotic figure has definite female characteristics.

GLOSSARY

bisect To divide into two equal parts.

compass A tool used for drawing circles and arcs and for measuring distances, consisting of two pointed legs joined together at one end.

contour The outline of a figure or body.

crown The top of the head.

devious Willing to lie to or trick others in order to get something.

drape To become arranged in flowing lines or folds.

ellipse Oval.

feisty Full of spirit, energy, or courage; spunky.

gouache An opaque and heavier form of watercolor paint, traditionally used in illustration.

guileless Innocent.

lapel Either of the two parts of a garment folded back on the chest, especially a continuation of a jacket or coat collar.

modeling The representation of color and lighting effects to make an image appear three-dimensional.

petticoat A skirt worn under a dress or outer skirt, often made with a ruffled, pleated, or lace edge.

pleats Folds of equal width made by doubling cloth upon itself and pressing or stitching the cloth in place.

proportion The relationship in size of one part of a work of art to another.

shading The representation of the different values of color, or light and dark, in a painting or drawing.

symmetrical Having two sides or halves that mirror or duplicate each other.

taper To become gradually narrower toward one end.

tomboy A girl who dresses or acts in a manner usually considered boyish.

torso The trunk of the human body.

upper The part of a shoe above the sole, covering the upper surface of the foot.

FOR MORE INFORMATION

Billy Ireland Cartoon Library & Museum
Ohio State University
27 W. 17th Avenue Mall
Columbus, OH 43210-1393
(614) 292-0538
Web site: http://cartoons.osu.edu
The Billy Ireland Cartoon Library & Museum is a compre-
 hensive research collection documenting American
 printed cartoon art. The library collects broadly repre-
 sentative examples of manga, as well as examples of the
 use of manga in selected fields, such as history, biography,
 science, religion, and government.

Cartoon Art Museum
655 Mission Street
San Francisco, CA 94105
(415) CAR-TOON [227-8666]
Web site: http://cartoonart.org
The Cartoon Art Museum is dedicated to the preservation
 and exhibition of cartoon art in all its forms, from edito-
 rial cartoons to comic books, graphic novels to anime.
 This unique institution houses approximately six thou-
 sand original pieces in its permanent collection. It also has

a library facility, a classroom for cartoon art, and a bookstore.

Japanese Canadian Cultural Centre (JCCC)
6 Garamond Court
Toronto, ON M3C 1Z5
Canada
(416) 441-2345
Web site: http://www.jccc.on.ca
For over forty years, the Japanese Canadian Cultural Centre has served as the gathering place for the Japanese Canadian community and for those of non-Japanese ancestry who have an interest in things Japanese. The JCCC offers a wide variety of Japanese cultural programs and experiences.

Japan Foundation, Los Angeles
333 South Grand Avenue, Suite 2250
Los Angeles, CA 90071
(213) 621-2267
Web site: http://www.jpf.go.jp/jfla
The Japan Foundation promotes international cultural exchange and mutual understanding between Japan and overseas countries. It provides a wide range of programs, including Japanese-language instruction and exchanges in the arts.

Kyoto International Manga Museum
Karasuma-Oike
Nakagyo-ku
Kyoto 604-0846

Japan
+81-75-254-7414
Web site: http://www.kyotomm.jp/english
The Kyoto International Manga Museum opened in
 November 2006 as the first comprehensive cultural
 center for manga culture in Japan. It has one of the
 world's largest collections of manga-related materials,
 holding approximately 300,000 items.

Museum of Comic and Cartoon Art (MoCCA)
594 Broadway, Suite 401
New York, NY 10012
(212) 254-3511
Web site: http://www.moccany.org
This museum's mission is to promote the understanding and
 appreciation of comic and cartoon art, as well as to
 detail and discuss the artistic, cultural, and historical
 impact of the world's most popular art form. Every genre
 of the art is represented, including manga and anime.

WEB SITES

Due to the changing nature of Internet links, Rosen
Publishing has developed an online list of Web sites related
to the subject of this book. This site is updated regularly.
Please use this link to access the list:

http://www.rosenlinks.com/mm/girl

FOR FURTHER READING

Cook, Trevor, and Lisa Miles. *Drawing Manga (Drawing Is Fun!)*. New York, NY: Gareth Stevens Publishing, 2011.

Doran, Colleen. *Girl to Grrrl Manga: How to Draw the Hottest Shoujo Manga*. Cincinnati, OH: Impact Books, 2007.

Galea, Mario. *Discover Manga Drawing: 30 Easy Lessons for Drawing Guys and Girls*. Cincinnati, OH: Impact Books, 2006.

Giannotta, Andrés Bernardo. *How to Draw Manga*. Mineola, NY: Dover, 2010.

Hart, Christopher. *Magical Girls and Friends: How to Draw the Super-Popular Action-Fantasy Characters of Manga*. New York, NY: Watson-Guptill, 2006.

Hart, Christopher. *Young Artists Draw Manga*. New York, NY: Watson-Guptill Publications, 2011.

Li, Chi Hang, Chris Patmore, and Hayden Scott-Baron. *The Complete Guide to Anime Techniques: Create Mesmerizing Manga-Style Animation with Pencils, Paint, and Pixels (Barron's Educational Series)*. Hauppage, NY: Barron's, 2006.

Marcovitz, Hal. *Anime (Eye on Art)*. Detroit, MI: Lucent Books, 2008.

Miyazake, Hayao, and Diana Wynne Jones. *Howl's Moving Castle: Volume 1 of 4*. San Francisco, CA: VIZ Media, 2005.

Price, Pamela S. *Cool Comics: Creating Fun and Fascinating Collections* (Cool Collections). Edina, MN: ABDO, 2007.

Robson, Eddie. *Comic Books and Manga* (Crabtree Contact). New York, NY: Crabtree, 2009.

Rosinsky, Natalie M. *Graphic Content! The Culture of Comic Books* (Pop Culture Revolutions). Mankato, MN: Compass Point Books, 2010.

Sautter, Aaron, and Cynthia Martin. *How to Draw Manga Warriors* (Edge Books). Mankato, MN: Capstone Press, 2008.

Taylor, Des. *Cartoons and Manga* (Master This!). New York, NY: PowerKids Press, 2012.

INDEX

C

Chartpak markers, 8
circle guides, 9
clothing, drawing
 battle armor, 66–67
 city suit, 47
 crop top and jeans, 64–65
 evening dress with scarf,
 62–63
 girl racer, 56–57
 hiking outfit, 48–49
 Pollyanna style, 54–55
 schoolgirl, 52–53
 summer dress, 50–51
 top and skirt, 46
 trench coat, 60–61
 warrior woman, 58–59
colored pencils, 6
coloring aids, 8–9
compasses, 9
computer, coloring on, 9
Copic markers, 8

D

drawing aids, 9
drawing paper, 6–7

E

erasers, 8
eyes, drawing, 15

F

faces, drawing
 eyes, 15
 front view, 13
 profile view, 14
figures, drawing
 back view, 11
 profile view, 12
 three-quarter view, 10

G

gouache, 9

H

hair, drawing
 black and spiky, 20
 blonde swept-back bob, 21
 center part, 18
 cropped red bob, 26
 curly ponytail, 22
 curly strands, 27
 green and spiky, 17
 with headband, 19

orange bob, 16
pink pigtails, 23
sleek and blue, 25
wild spikes, 24
hands and arms, drawing
beckoning arm, 32
hanging loose, 30
waving arm, 33
waving open hand, 31

inking pens, 8, 9

L

layout paper, 6, 9
lead, pencil, hard and soft, 7
legs and feet, drawing
kicking out, 36
profile of foot, 34
shoes, 38–45
stepping off, 37
top of foot, 35
Letraset markers, 8

M

manga, explanation of, 4
marker paper, 6, 9
markers, 6, 8–9
mechanical pencils, 7

P

paint, 7, 8, 9
paper, 6–7, 9
pencils, 6, 7, 9
Pentel brush pen, 8
Pentel sign pen, 8

R

rulers, 9

self-propelling pencils, 7
sharpeners, 7–8
shoes, drawing
ballet flat, 41–42
chunky-heel boot, 43
leather slip-on, 44–45
red ankle boot, 38–39
school shoe, 40

T

tracing paper, 6

W

watercolor paper, 7
watercolors, 6–7

ABOUT THE AUTHORS

Anna Southgate is an experienced writer and editor who has worked extensively for publishers of adult illustrated reference books. Her recent work has included art instruction books and providing the text for a series of six manga titles.

Keith Sparrow has read and collected comics since he was a child. He has created hundreds of storyboards, including one for the animation movie *Space Jam*, and illustrated several children's educational books for the UK's Channel 4 and the BBC. He became a fan of manga and anime after reading *Akira*.